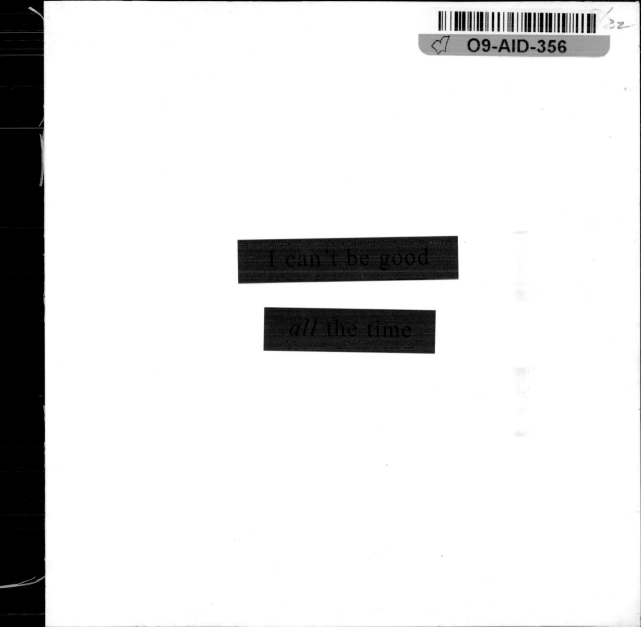

I can't be good

all the time

... I can't be good all the time ...

An Anne Taintor Collection

Anne Taintor

CHRONICLE BOOKS
SAN FRANCISCO

Library of Congress
Cataloging-in-Publication
Data available.

ISBN 0-8118-4140-5

Manufactured in China.

Designed by Laura Crookston

Distributed in Canada by
Raincoast Books
9050 Shaughnessy Street
Vancouver, British Columbia V6P 6E5

10 9 8 7 6 5 4

Chronicle Books LLC
85 Second Street
San Francisco, California 94105
www.chroniclebooks.com

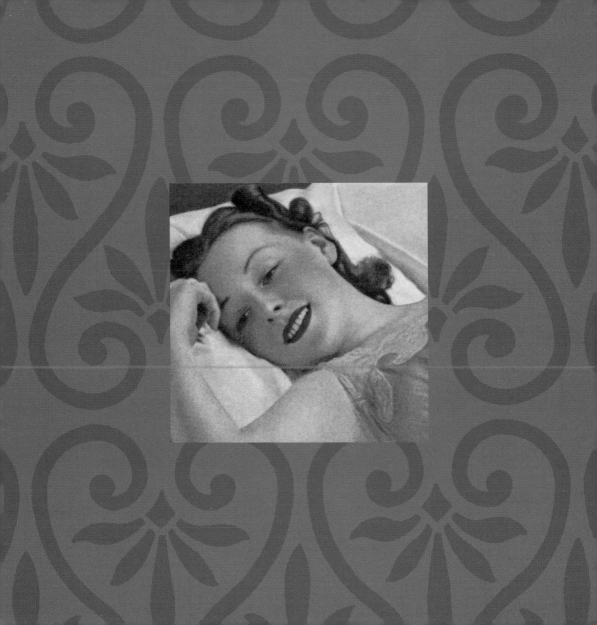

introduction

I haven't always been a bad girl. In grade school I was considered a goody-two-shoes, even the nuns thought so. But life does change one. There were temptations and opportunities, men and marriages, parties and mayhem. Eventually, I realized that I wasn't such a good girl anymore . . . and that I was having a lot more fun.

I love that my work makes people laugh. I can't take all the credit, though; everyone in my family talks exactly like the women on these pages. I guess it's no surprise that I found myself carrying on the tradition.

Let's face it, being bad is better. In times of doubt, may this book remind you that we can't be good all the time. Besides, who wants to try?

—**Anne Taintor**

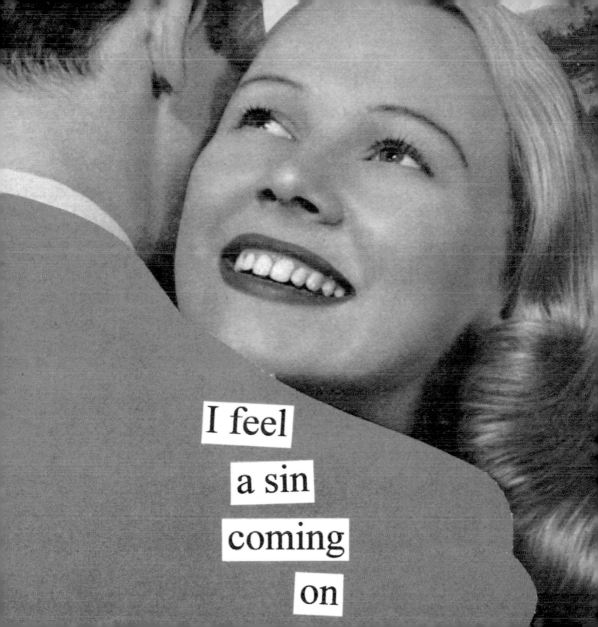

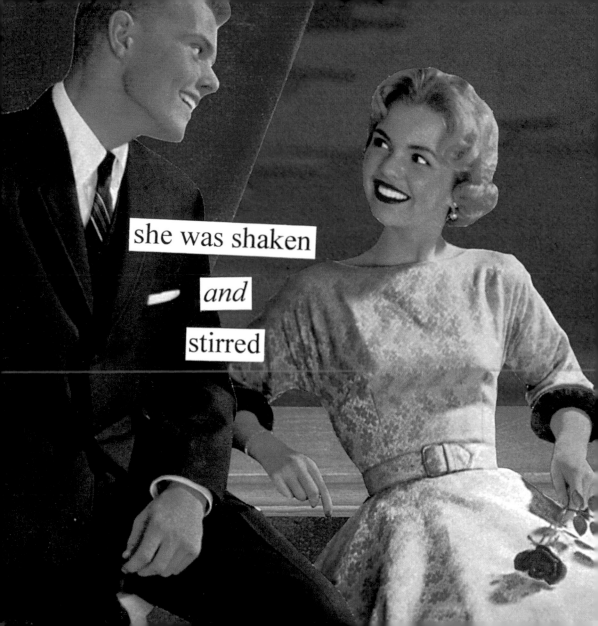

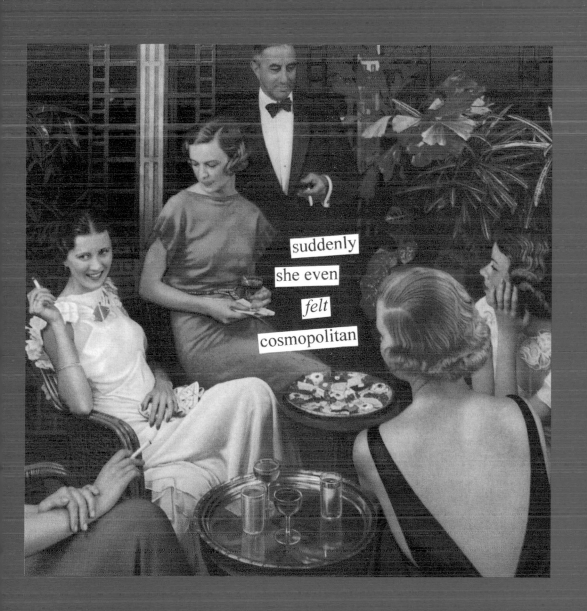

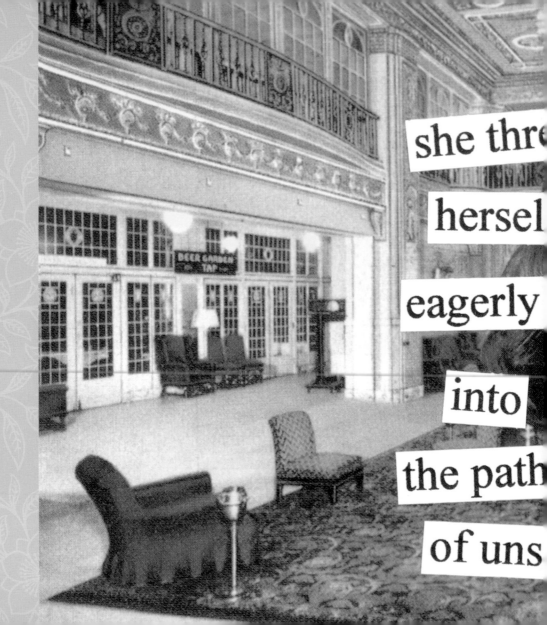

she thre
hersel
eagerly
into
the path
of uns

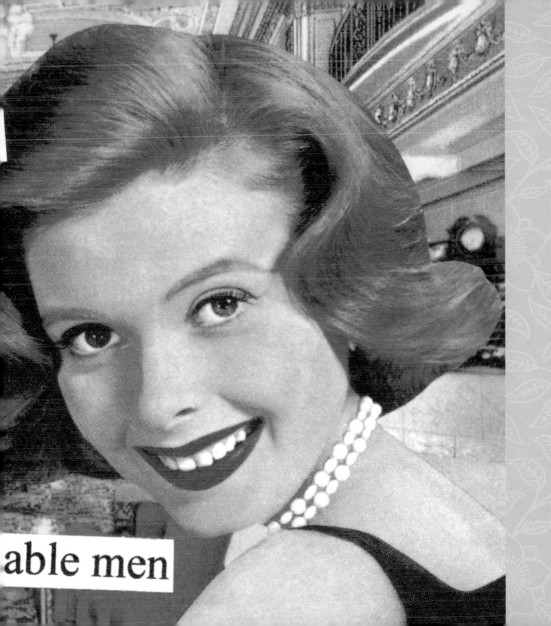

able men

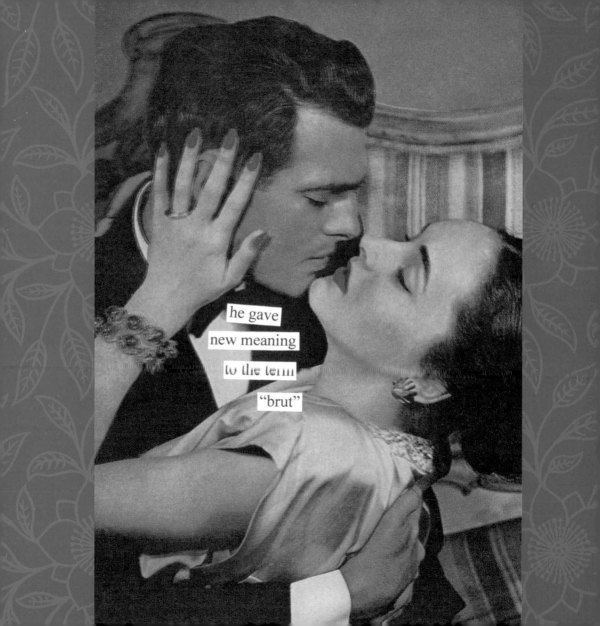

he gave
new meaning
to the term
"brut"

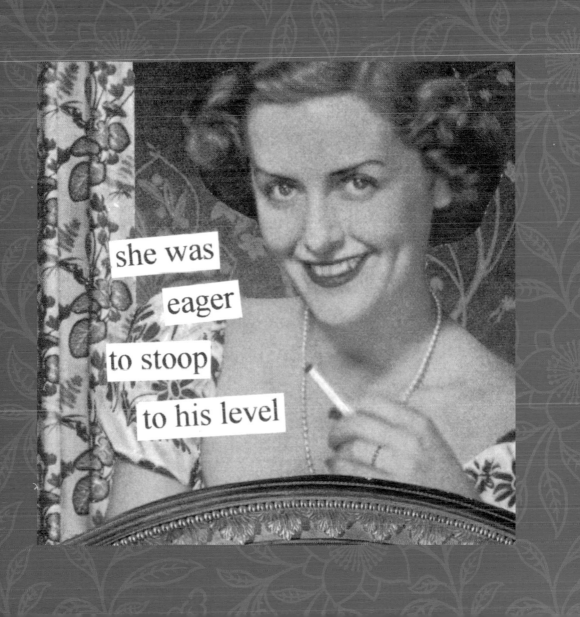

she was

eager

to stoop

to his level

born to

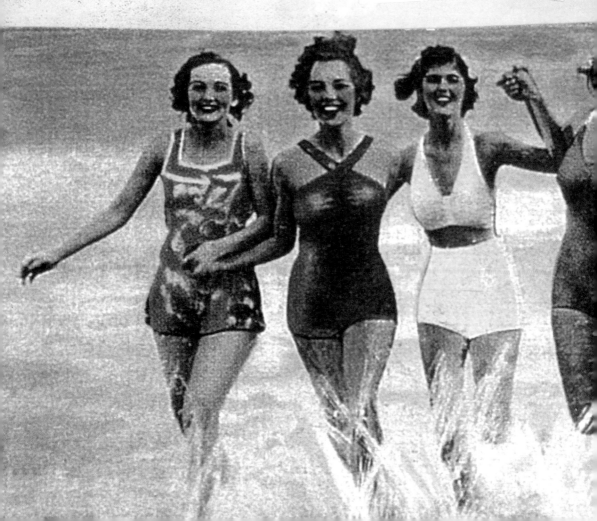

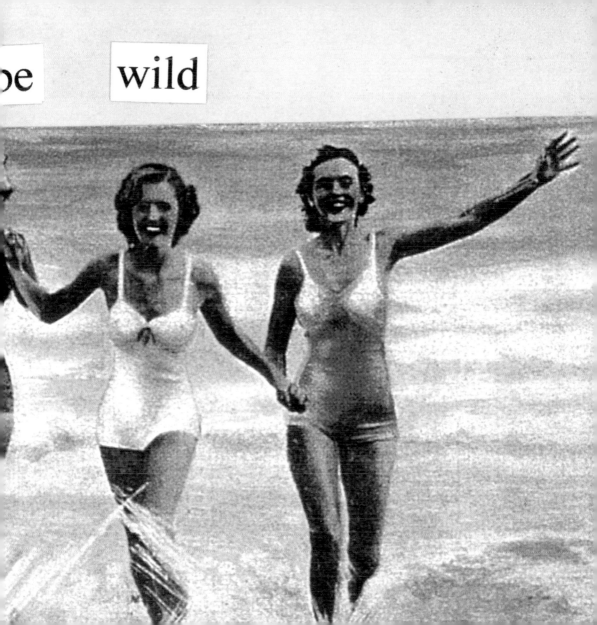

she was tempted

to cause a scene

maybe

I *want*

to look

cheap

she refused
to let
common sense
cloud her judgement

gee...

she had an opinion

about

everything

it's not the meat, it's the motion

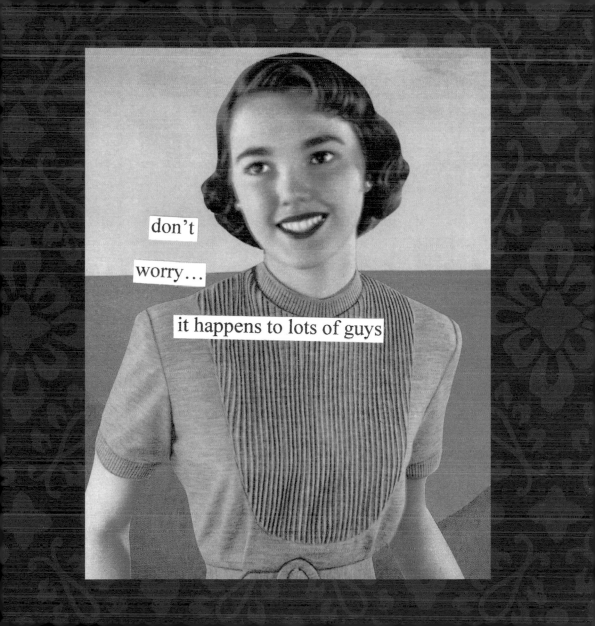

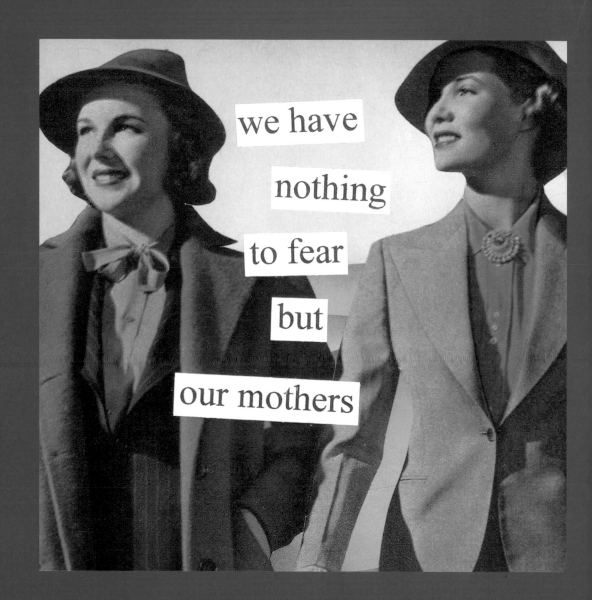

it's always fun until someone puts out an eye

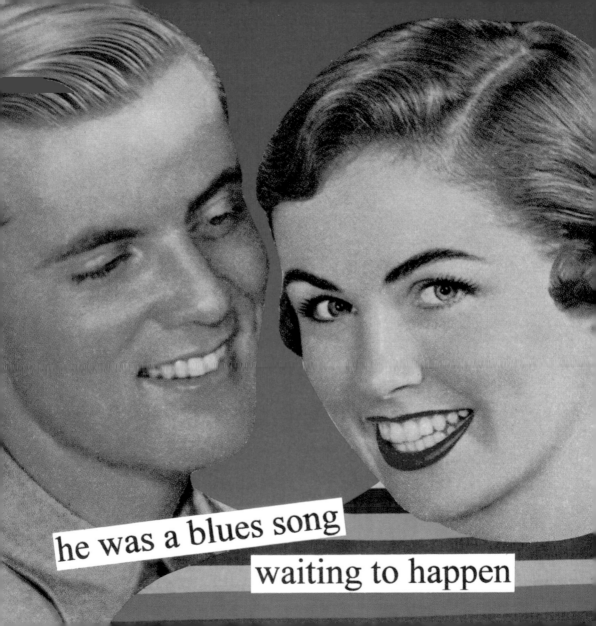

he was a blues song
waiting to happen

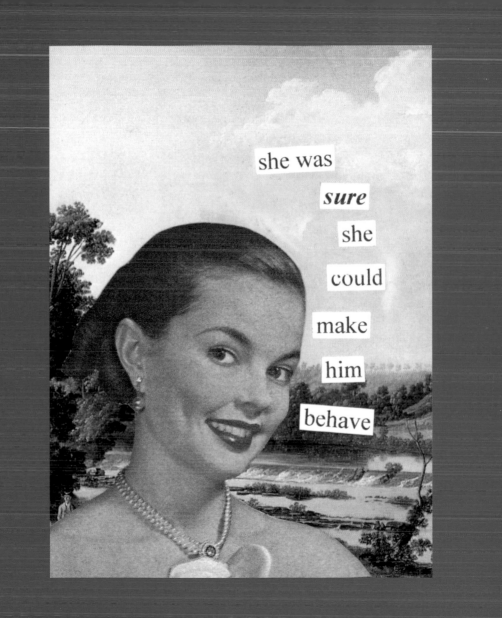

there's
such a thing
as being
too
emotionally accessible

it's so *involved* being me

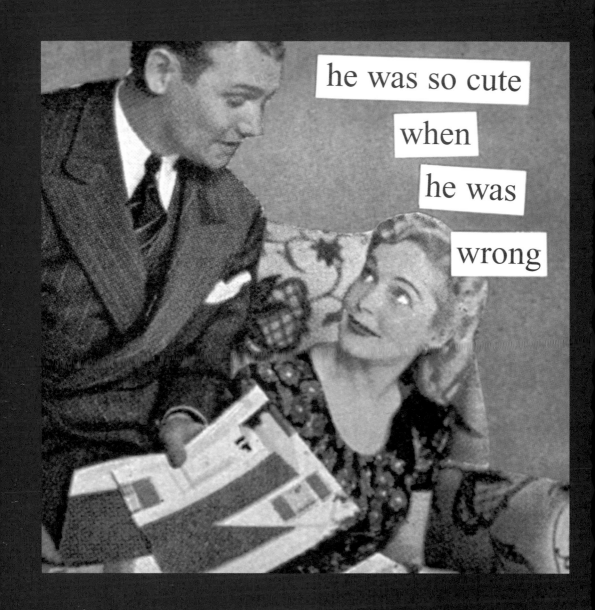

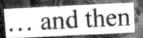

... and then
I ripped
his lungs out

nothing
you say
can shock *me*,
honey

she liked her men
like her wines...
robust, with a long finish

his story

was thoroughly researched

and delivered

with great dramatic flair

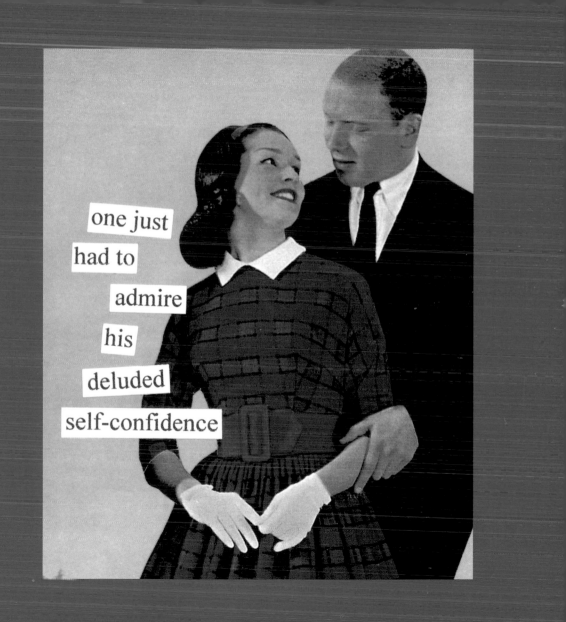

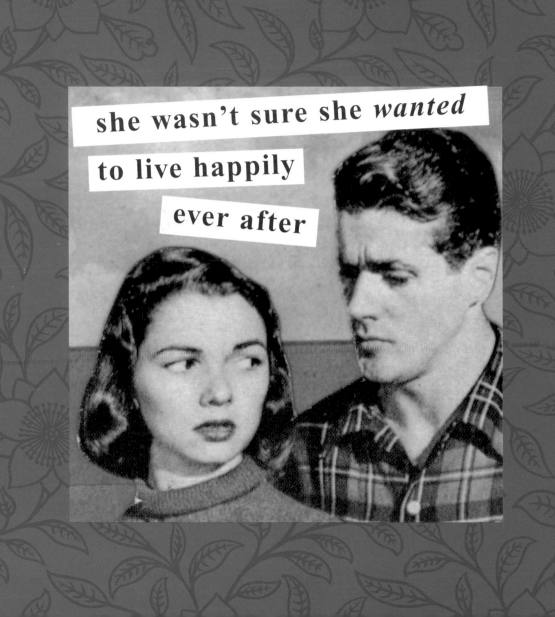

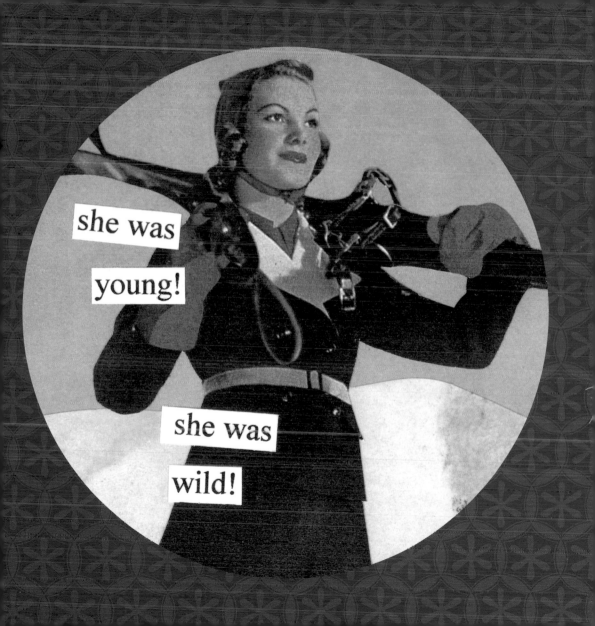

he was not
as fascinating
as he had once appeared

...and then

she realized:

they *were* all alike!

perhaps
it was time
to try
a different corner

break a leg,
honey

it would,
of course,
have to look
like an accident

had she
punished him
enough?

how could
she be sure?

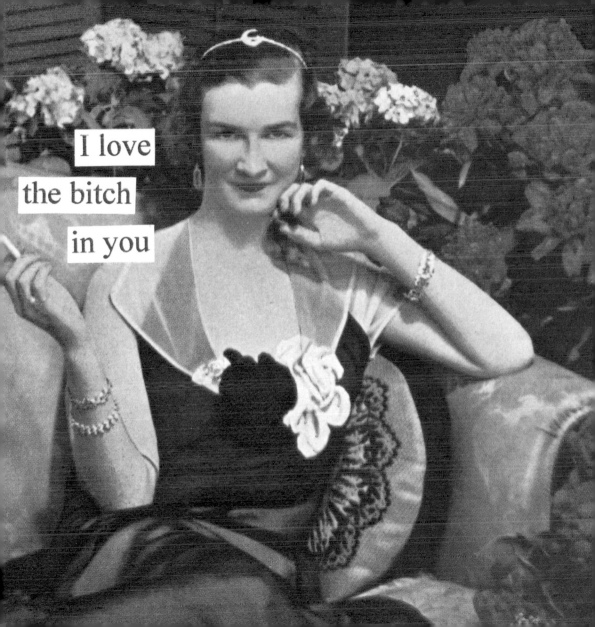

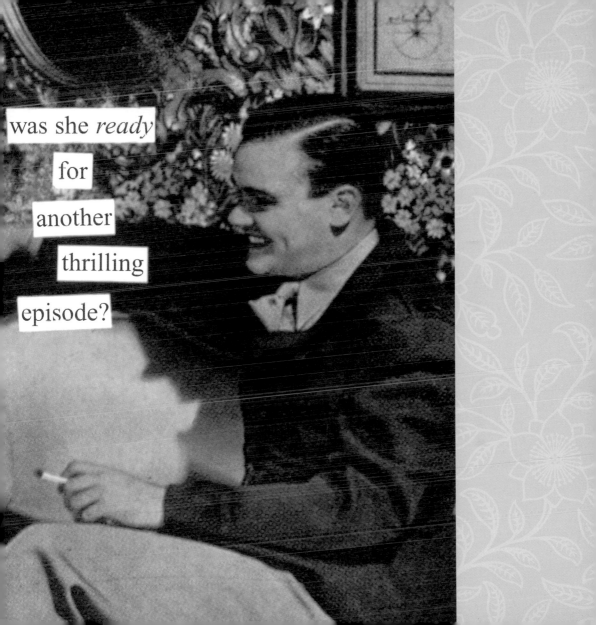

was she *ready* for another thrilling episode?

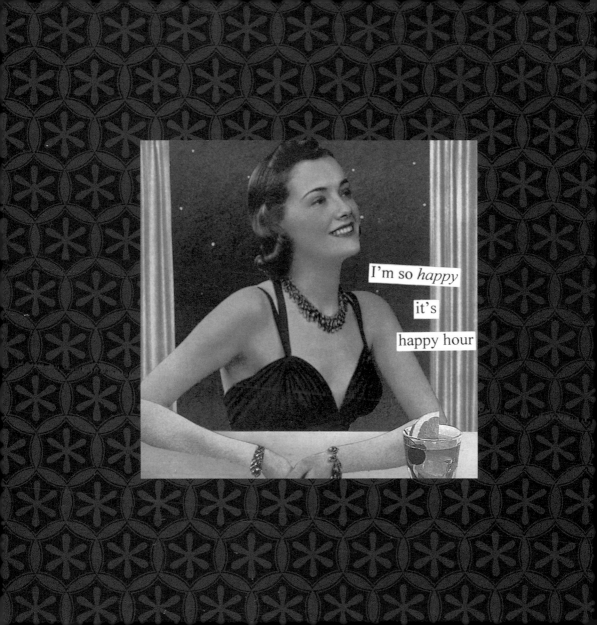

all I want

is

an umbrella

in my drink

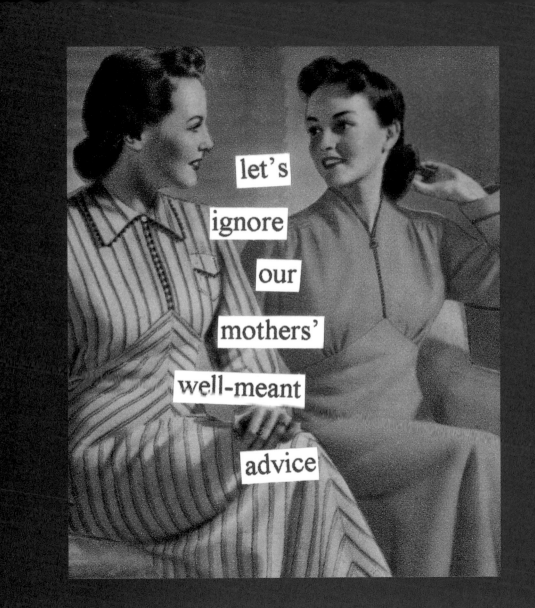

she sincerely

hoped

that

he

would

keep them coming

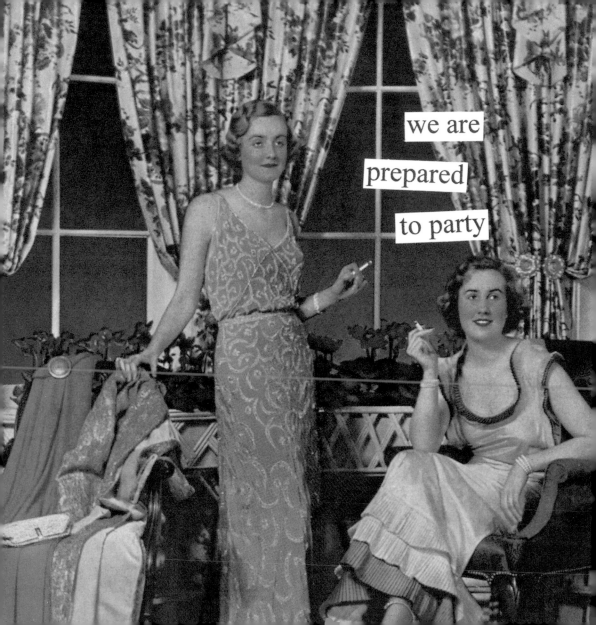

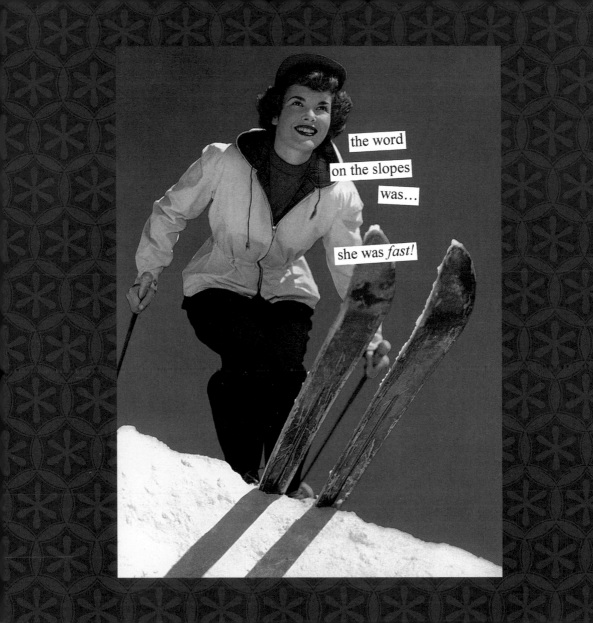

she objected
to
the term
"tramp"

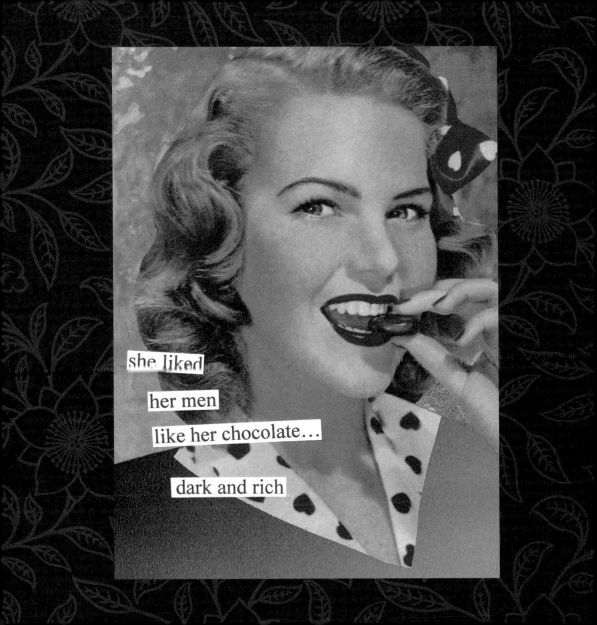

she liked

her men

like her chocolate...

dark and rich

she liked

her men

like

her cocktails...

neat, but with a twist

finally
she had convinced him
that she would still
respect him
in the morning

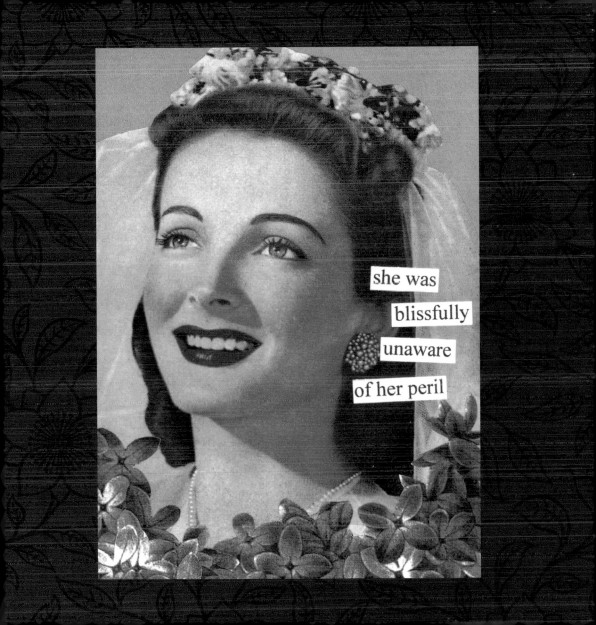

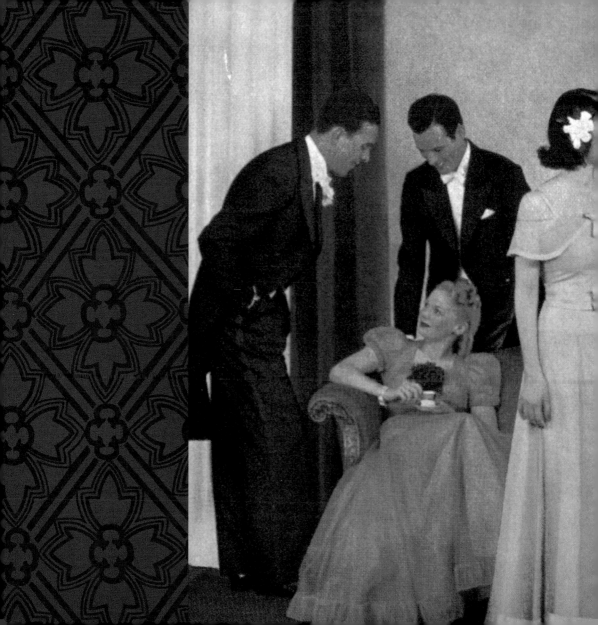

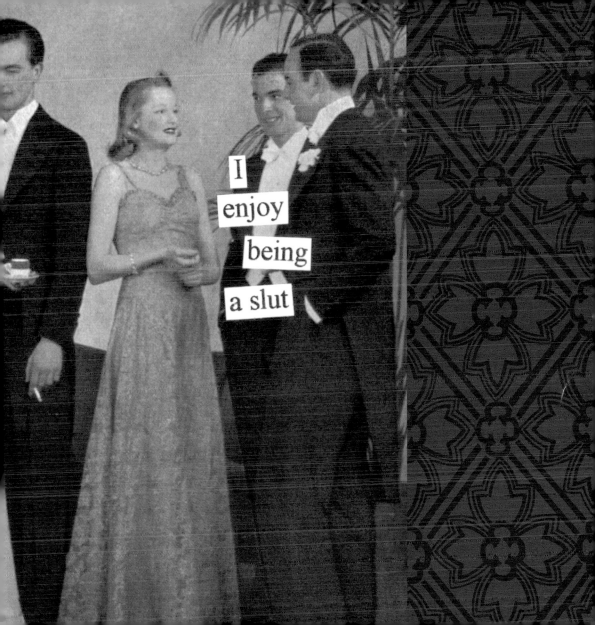

I

enjoy

being

a slut

she had
told him
that
she liked to
swing

she thought
of herself
as
a work
in progress

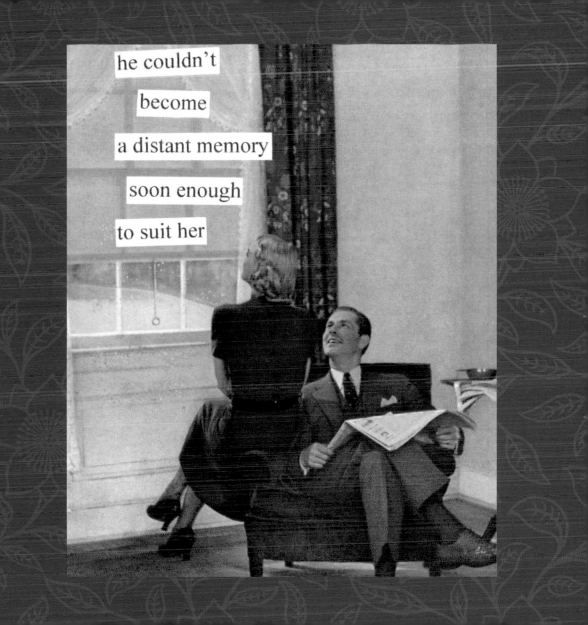

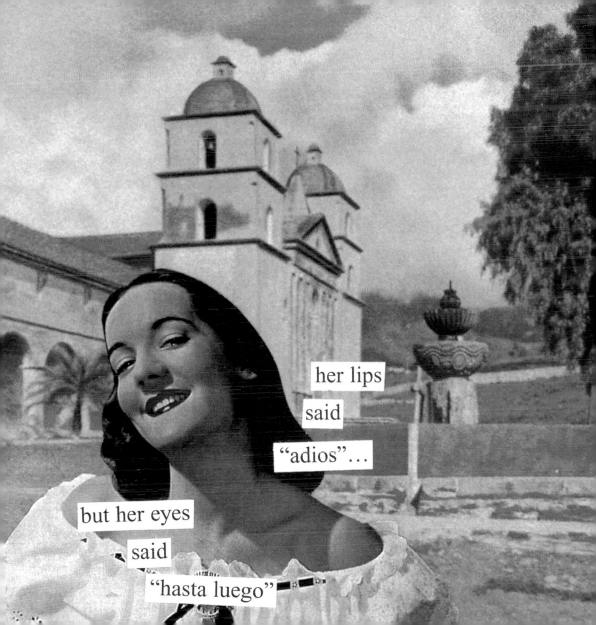

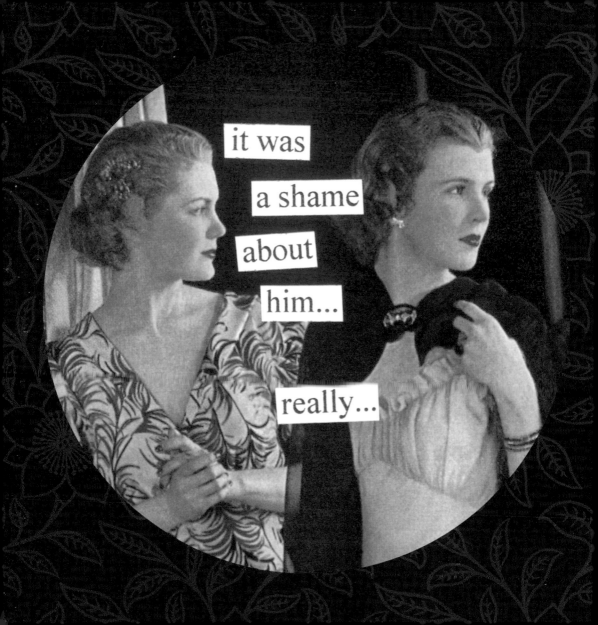

she was really

quite impressed

by his

breath control

she was over him at last

she could

hardly wait

to be

back in

the saddle again

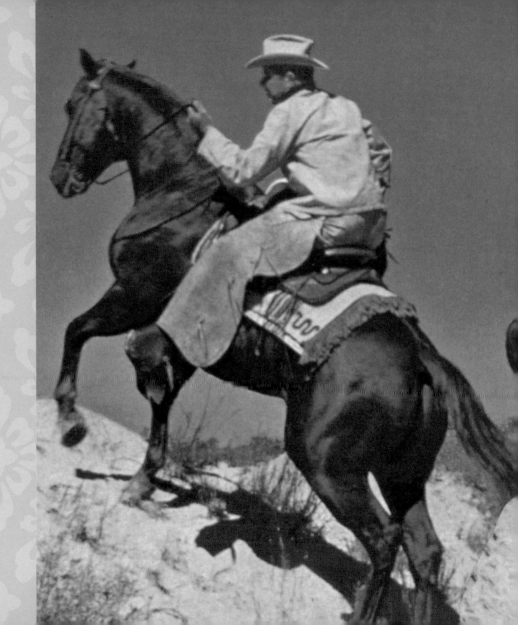

she thought of them as…

a 4H project

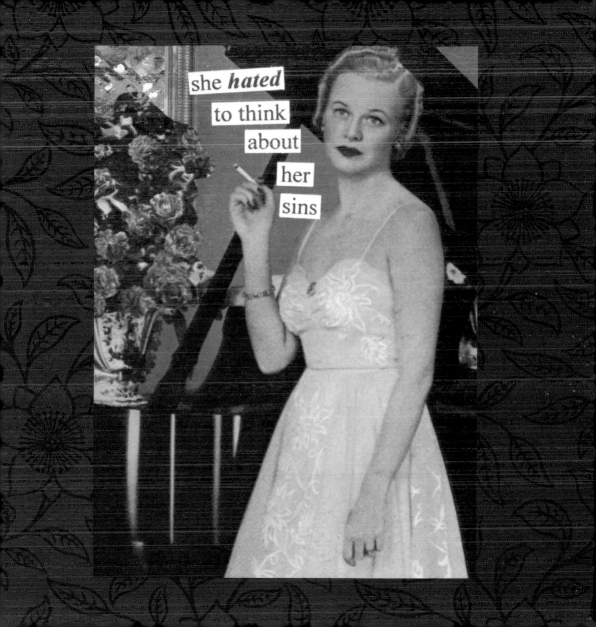

she *hated*
to think
about
her
sins

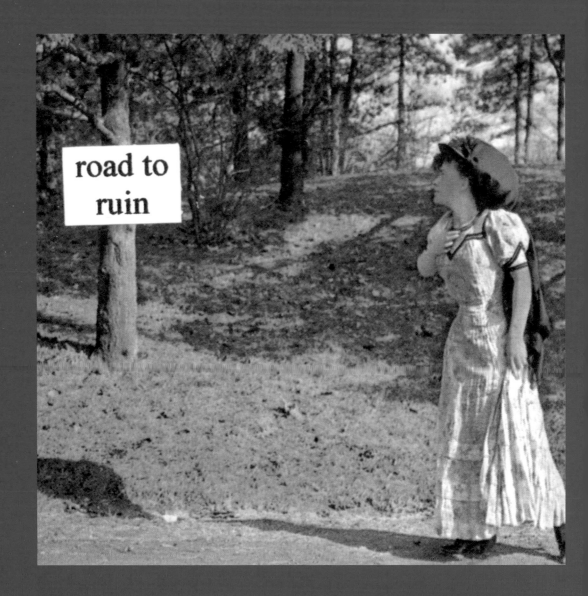

the nuns
were still
just one step behind her

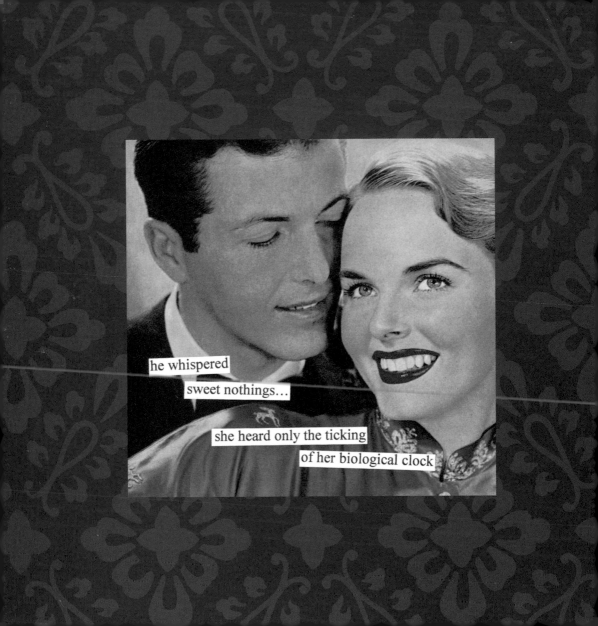

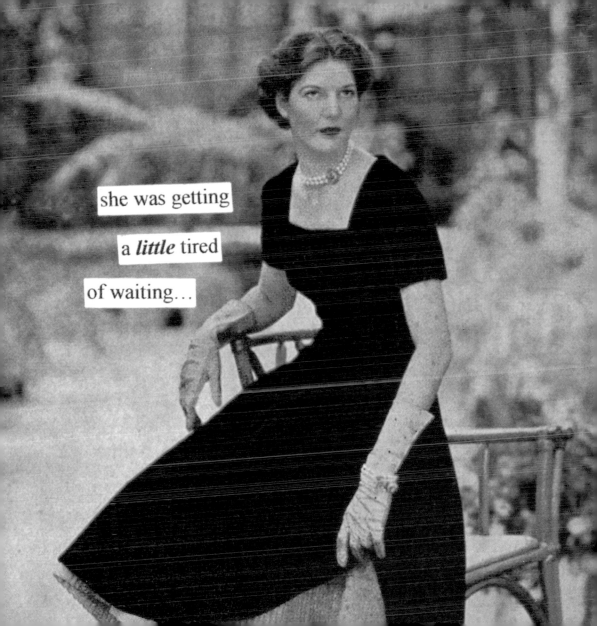

she was getting

a *little* tired

of waiting…

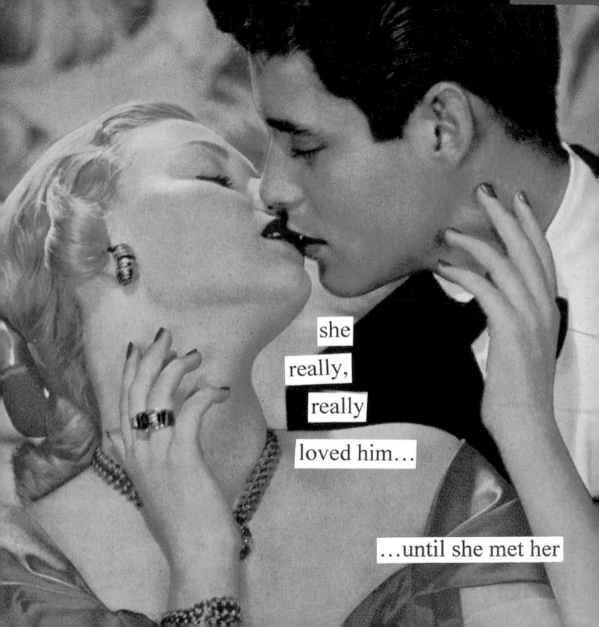

she
really,
really
loved him...

...until she met her

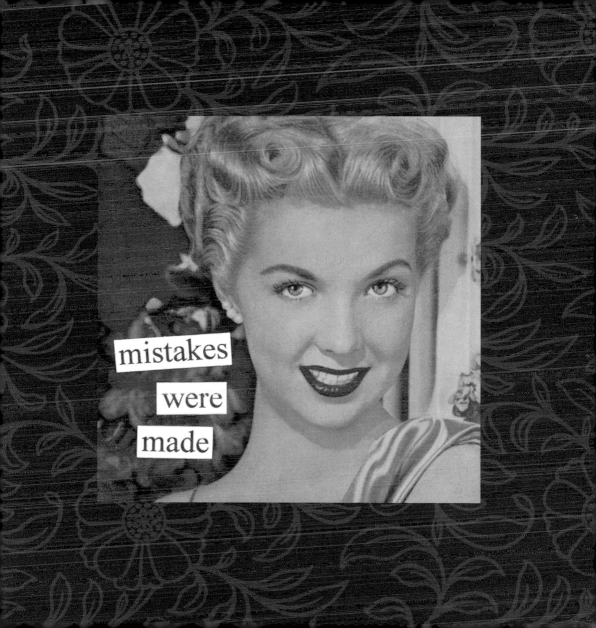

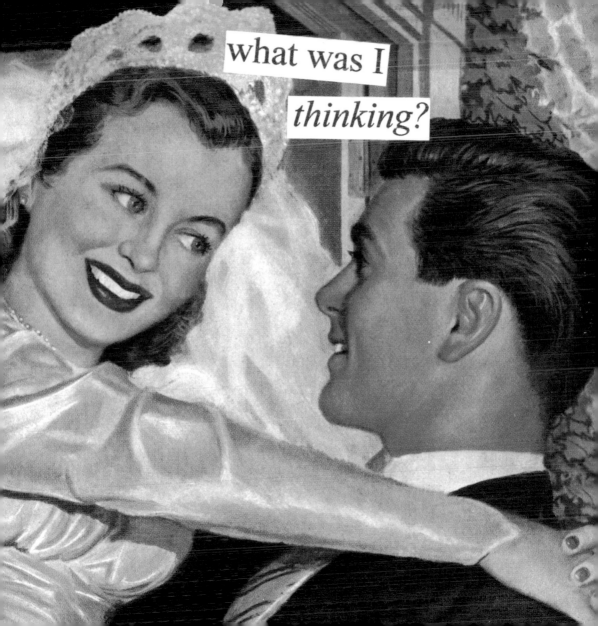

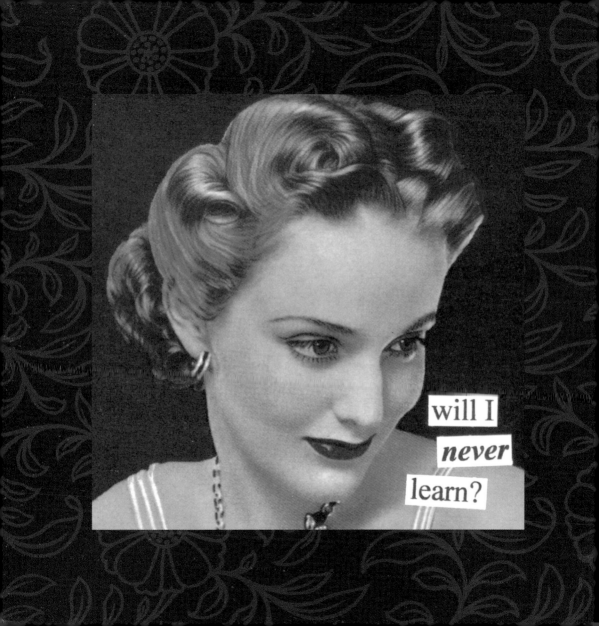

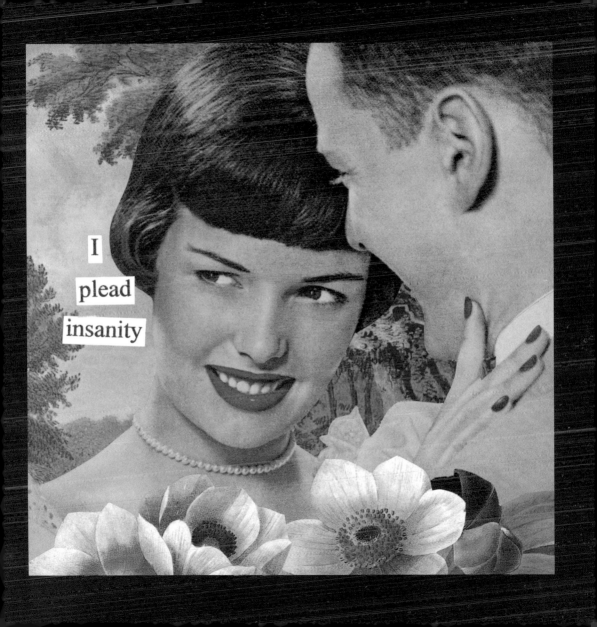

she had learned
to be
a bit more careful

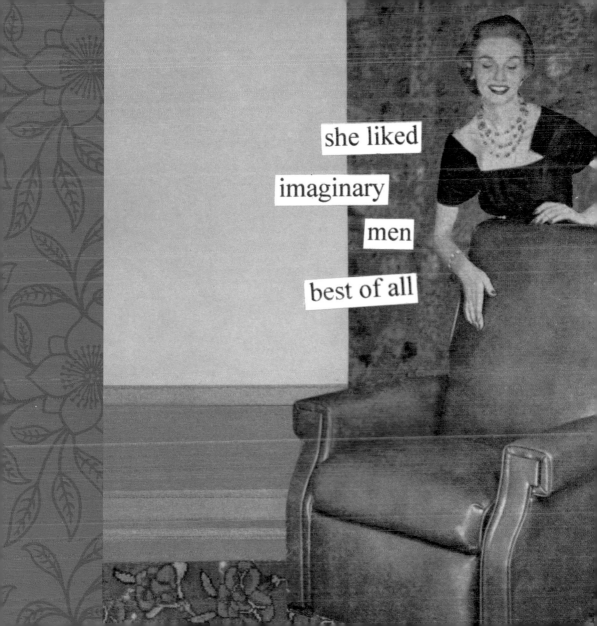

bitter? moi?

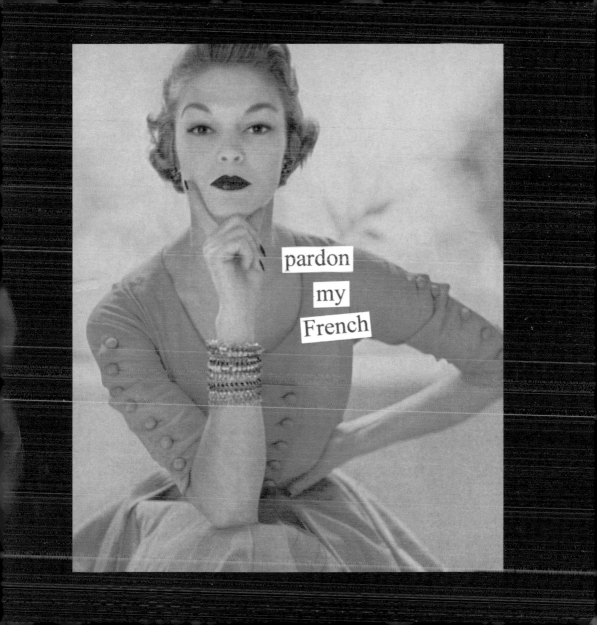

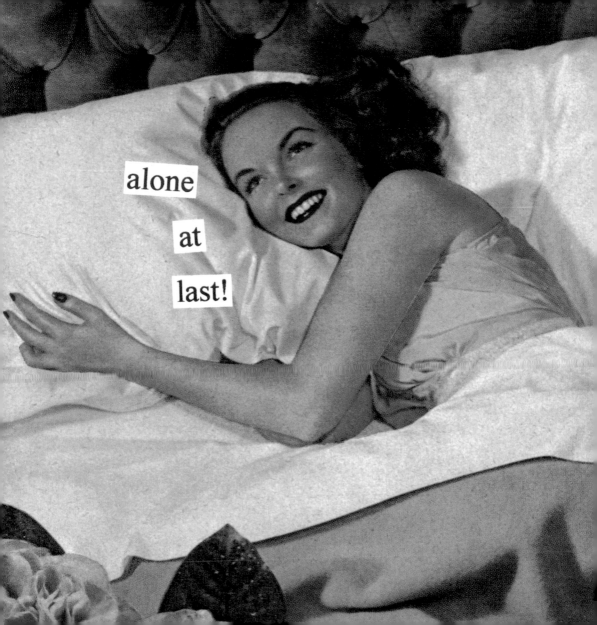

alone at last!

I can't
be good
all the time